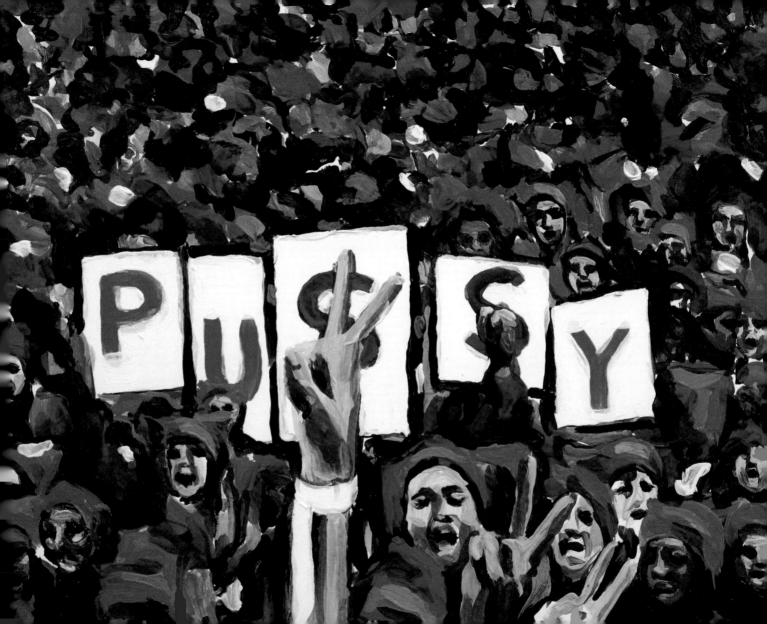

Please Don't Grab My Pussy:
A Rhyming Presidential Guide
Copyright © 2018

Animal Media Group books may be ordered through booksellers, or by contacting:

Animal Media Group
100 1st Ave suite 1100
Pittsburgh, PA 15222
animalmediagroup.com
(412) 566-5656

The views expressed in this work are solely those of the author, and do not necessarily reflect the views of the publisher, and the publisher hereby disclaims and responsibility for them.

ISBN: 978-1-947895-02-7 (pbk)
ISBN: 978-1-947895-03-4 (ebk)

Mr. President, you seem confused
And a lot of my cousins do, too
About what can and can't be grabbed
So please let me clarify for you

There are plenty of things you can grab
Besides my twin peaks and high tush
So if you're confused, just read this book
And please don't grab my Billy Bush

You can grab a ride on your private jet

The leather seats are so soft and cushy

Get some rest before you tweet

But please don't grab my pussy

You can grab an electoral map of your victory
Yes, we all know you won North Carolina
Talk about states I'll never set foot in
But please don't grab my vagina

You can grab the attention of the NSA

By searching "bomb" on your computer

My porn's in a folder called "Sinkhole Collection"

But please don't grab my cooter

You can grab a look at my Spotify playlist
I do like that kid Justin Bieber
Tell him to follow me back on Instagram!
But please don't grab my beaver

You can grab a bus to my Aunt's commune
She'll make you bathe in mud
Ask her about her lazy eye
But please don't grab my rosebud

You can grab your brand new putter

Wow—you got five under par?

You know everyone lets you win, right?

But please don't grab my wet bar

You can grab a joint in California
It's legal there to puff
I can't smoke 'cause I get too anxious. Sad!
But please don't grab my muff

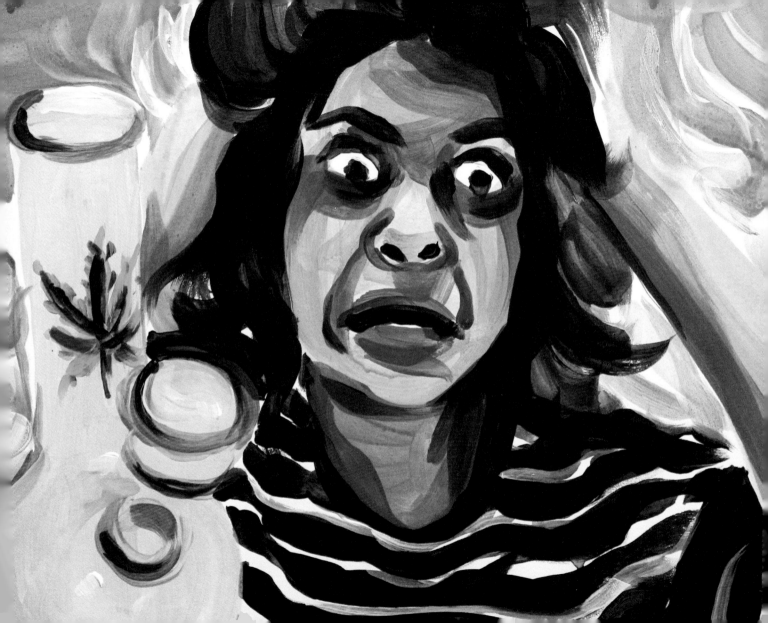

You can grab the wheel of your boat

Learn to tie a sailor's knot

My old roommate went missing on a cruise

But please don't grab my twat

The New York Times

OLLEGE GIRL VANISHES AT SEA

PRING BREAK CRUISE GONE AWRY

RIEVING
OOMMATE
PISSED

EYEWITNESSE:
FEEL LIKE
THEY KNOW
WHO DID IT

You can grab a dermatologist appointment
I hope that mole isn't skin cancer
I hear it's very treatable
But please don't grab my panty hamster

You can grab a chat with Michael Phelps
Ask him how he swims the butterfly
Tell him to follow me back on Instagram
But please don't grab my tuna pot pie

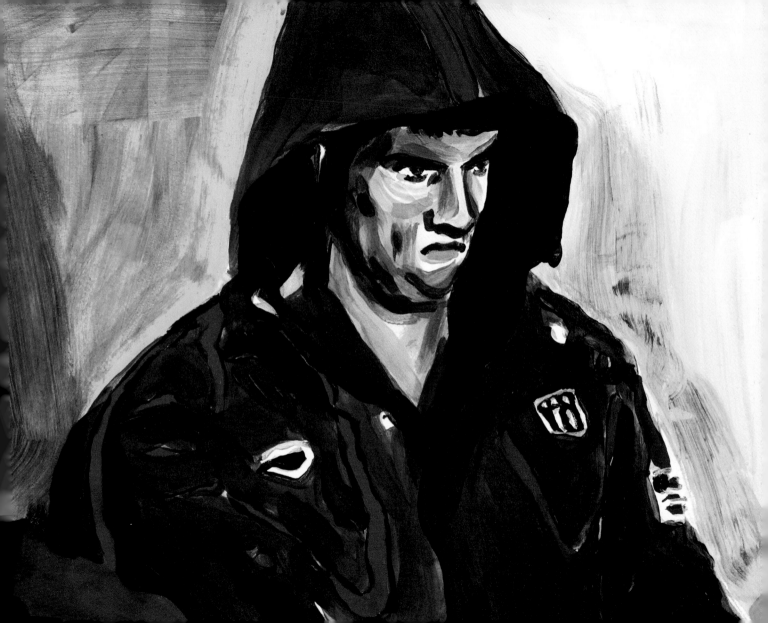

You can grab my *Sex and the City* DVDs
Do you think Miranda is still with Steve?
I once saw Cynthia Nixon at a charity ball
But please don't grab my wizard's sleeve

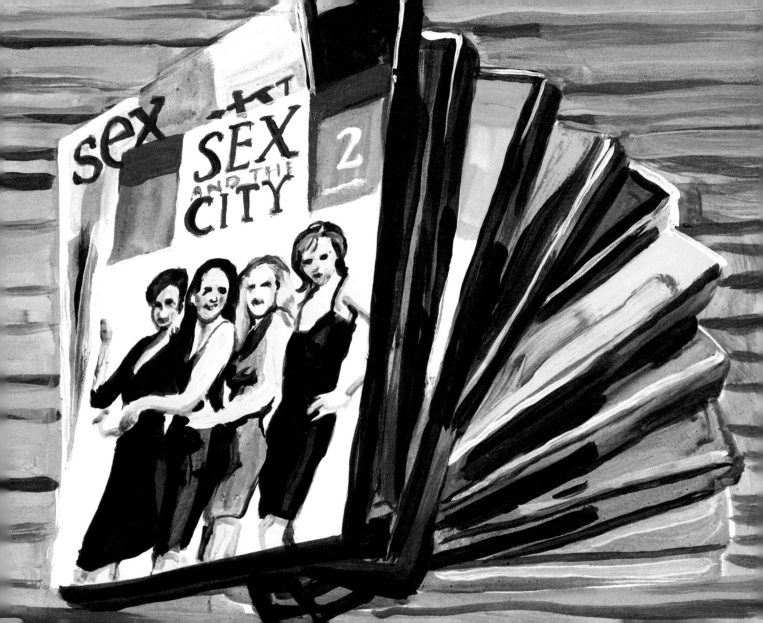

You can grab a bottle of Pantene

Go from dirty blond to brunette

(Fallon handed you the election)

But please don't grab my Carly Simon cassette

You can grab a second opinion
About that irregular mole
Turns out it's very serious
But please don't grab my piss hole

DR. PLEM
DERMATOLOG

You can grab Mike Pence (that's fine)
You know he calls his wife "mother"?
He sleeps standing up, like my horses
But please don't grab my lady udder

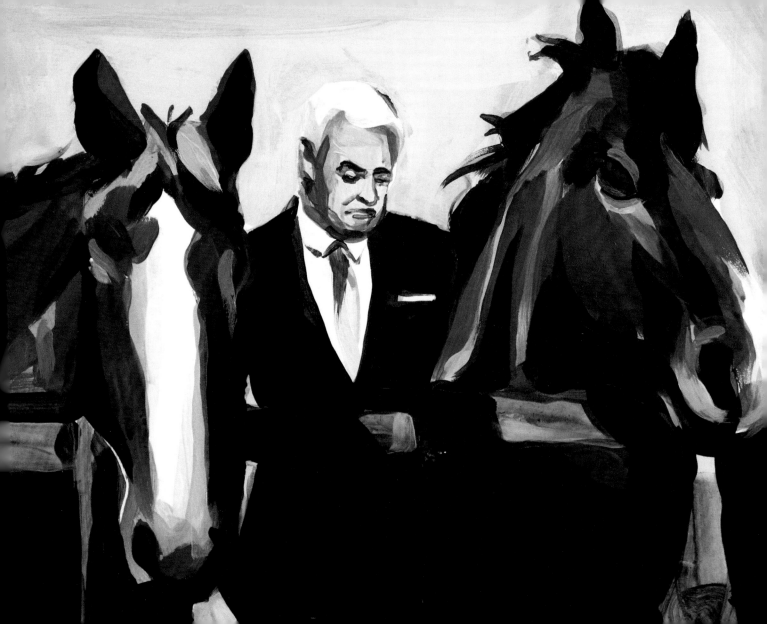

You can grab a bucket of KFC
Pick up a drumstick and munch it
Wipe the grease off on your long tie
But please don't grab my queef trumpet

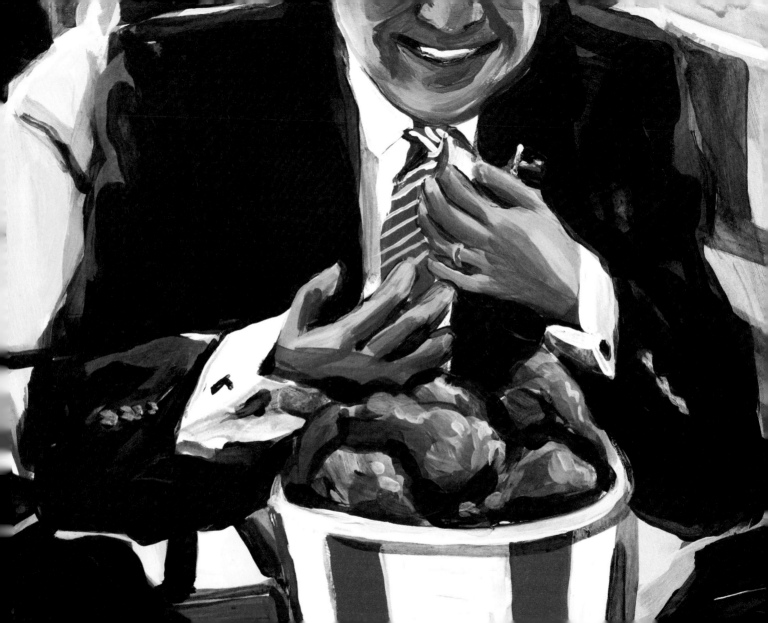

You can grab the remote and put on Hannity
That guy is one loud talker
Tell him to unfollow me on Instagram
But please don't grab my meat locker

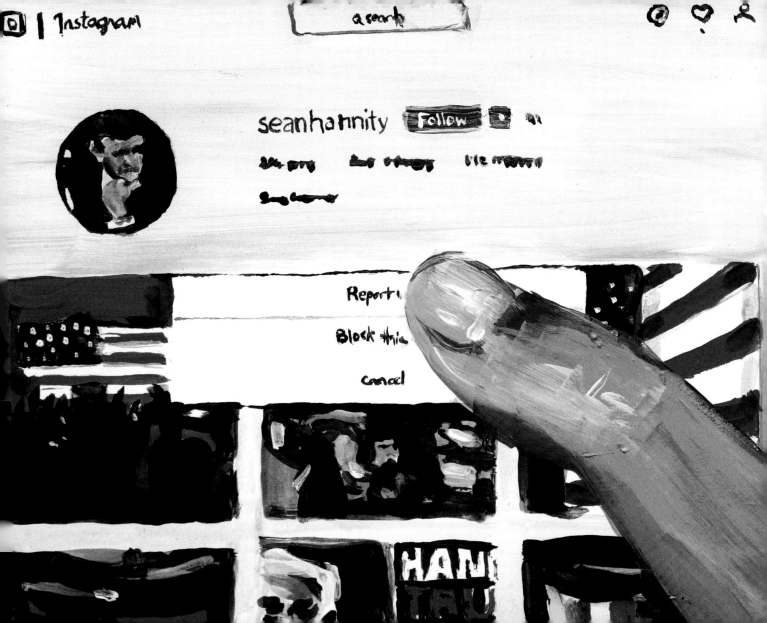

You can grab a surgeon for your mole removal

Call up Dr. Oz or Dr. Drew

I dunno, just figure it out, okay?

But please don't grab my skin canoe

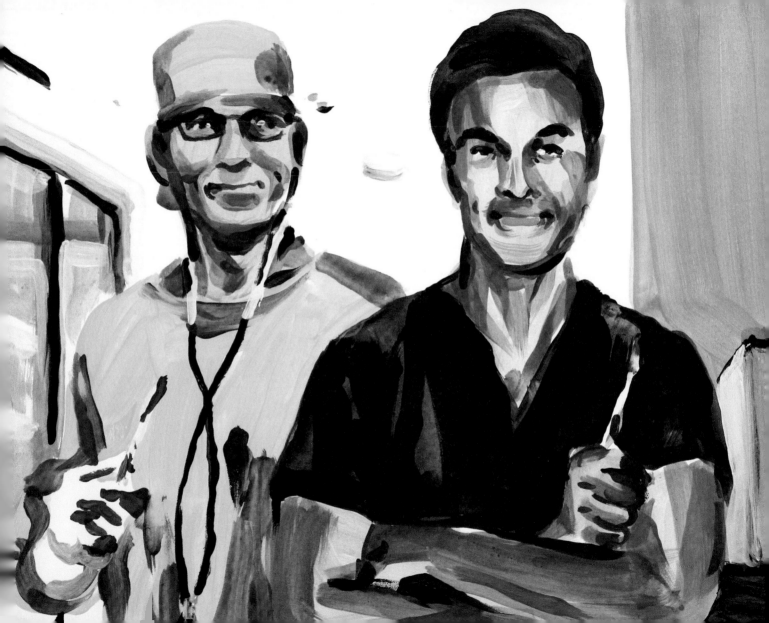

You can grab the confidence of a supermodel

Walk the runway like Gisele

Did you know she has a twin named Patricia?

But please don't grab my dildo hotel

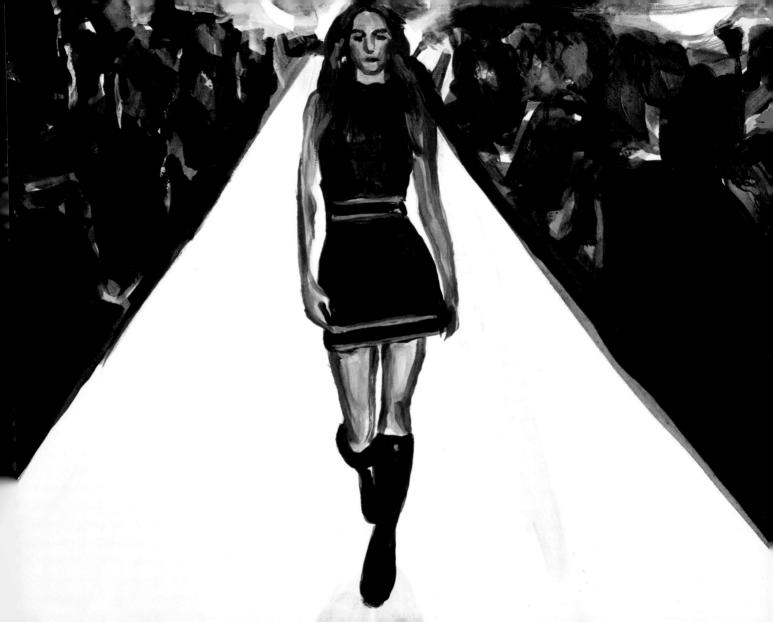

You can grab a meal at Mar-A-Lago

My steak was unsatisfactory

It tasted like how being screamed at by Don Jr. feels

But please don't grab my yogurt factory

You can grab your adult coloring book
Your favorite crayon shade is "Caucasian"
Try to color inside the lines this time
But please don't grab my crusty crustacean

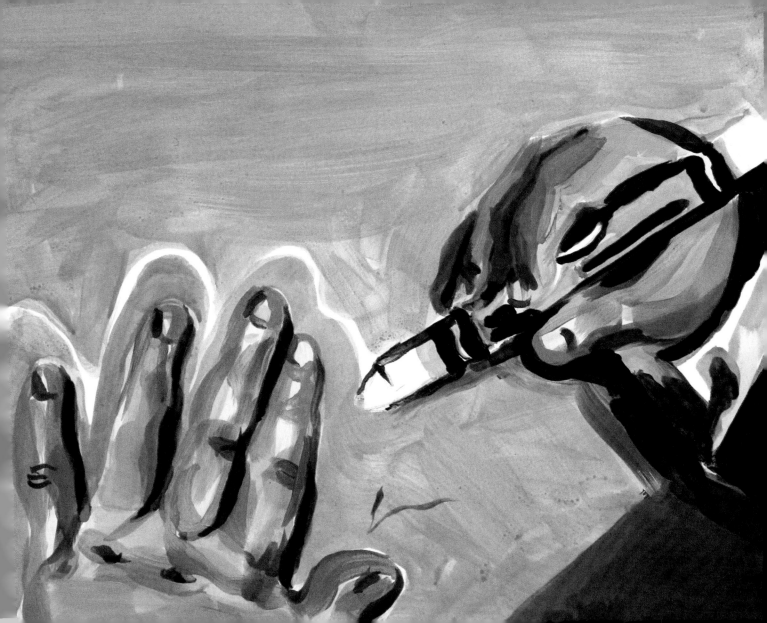

You can grab an extension on your taxes

As part of your elaborate con

I know for a <u>fact</u> there's a pee tape

But please don't grab my hippo's yawn

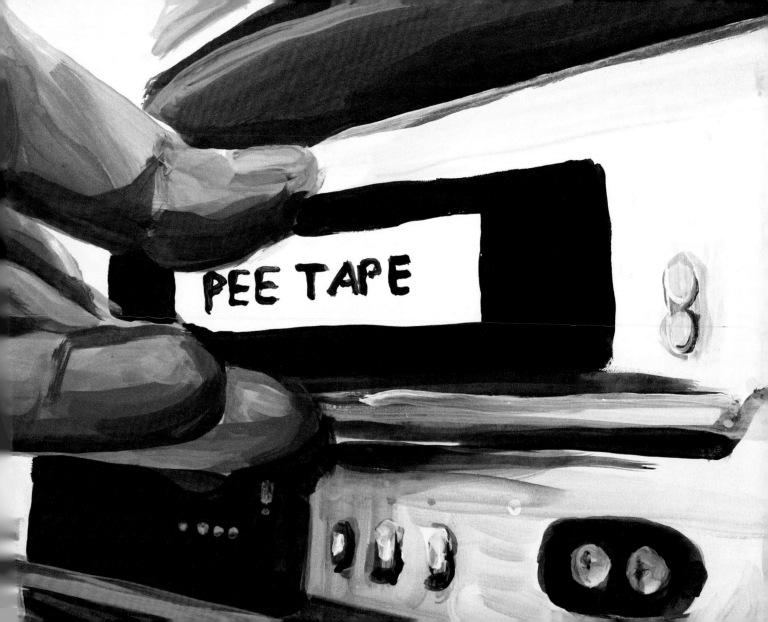

You can grab the election from Hillary

Putin pulled off one hell of a hack

You lost the popular vote by three million

But please don't grab my front crack

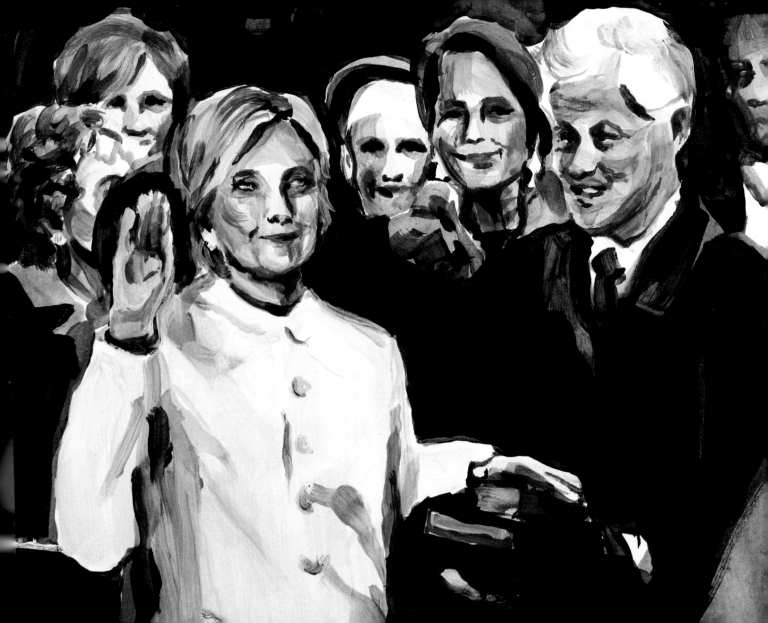

This was a list of things you can grab

And yes, I'm gonna sound pushy

For once in your life, listen up

DON'T EVER FUCKING GRAB MY PUSSY

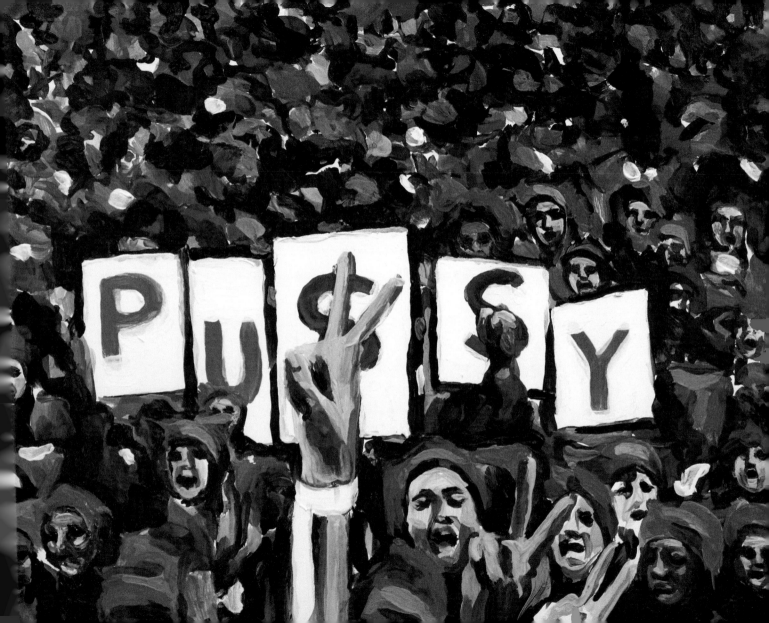

Julia Young is a NYC-based writer and comedian. She currently appears on MTV's *Wild 'N Out* and has written for such shows as *Brain Games*, *Girl Code*, *Ladylike*, *Hack My Life*, *Impractical Jokers*, and *Billy On The Street*. Visit her website at juliabyoung.com.

Matt Harkins is a comedian and the co-creator of the THNK1994 Museum, a pop culture museum based in Brooklyn. Visit the museum's website at THNK1994.com.